Oy Vey!

A
YIDDISH
COLORING BOOK?

by **Meish Goldish**

Art by **Freddie Levin**

BEHRMAN HOUSE
www.behrmanhouse.com

For my dear parents,
who spoke Yiddish when they didn't want me to
know what they were saying;

and for my dear grandparents, who always
translated for me.
—MG

For Bubby and
Zaidy, and *der
ander Bubby*.
—FL

Project Editor: Ann D. Koffsky
Designer: Annemarie Redmond

Published by Behrman House, Inc.
Springfield, NJ 07081
www.behrmanhouse.com
ISBN: 978-0-87441-967-2
Printed in the United States of America

A Yiddish coloring book for adults?

Right now you're probably asking yourself:

Why?

The answer, of course, is: *Why not?* After all, coloring books are no longer just for kids. Recent studies show that coloring can help adults relieve stress. And God knows the stress that we adults are under these days! Your Uncle Morty borrowed $1,000 six months ago and has yet to pay back a single penny . . . that *shmendrik*! Plus, lately you've been feeling a pain in your

☐ legs ☐ back

☐ neck ☐ *tuchus*

(check the appropriate blank), and your doctor can't pinpoint the cause. Not to mention your unemployed brother-in-law who's coming to your home for a "short visit." (Measure it with a calendar.)

So the need to relieve stress, you definitely have.

But why a *Yiddish* coloring book? That's obvious. Yiddish is a colorful language. So its words deserve to be colored! That makes perfect sense to me, especially since I have a *Yiddishe kup*—a Jewish way of thinking.

Of course, the naysayers will tell you that Yiddish is a dying language. I disagree. I say it's a dye-ing language. So use dye. Or crayons. Or colored pens and pencils. Or water paint. Or markers. Whichever medium you choose, use it to make Yiddish the colorful language it most certainly is.

Nu, so what are you waiting for? Start relieving your stress! Steal a little time from your hectic schedule and spend it creating colorful Yiddish words.

Turn the page, begin to color, and . . . ahhh, what a *mechaya*! (That means "pleasure.")

—Meish Goldish

alta cocker

AWL-tuh KOK-ur

An *alta cocker* is a grouchy old man.

———————————————

The *alta cocker* sits on his porch all day,

complaining to his dog.

His dog also complains.

It's an *alta cocker* spaniel.

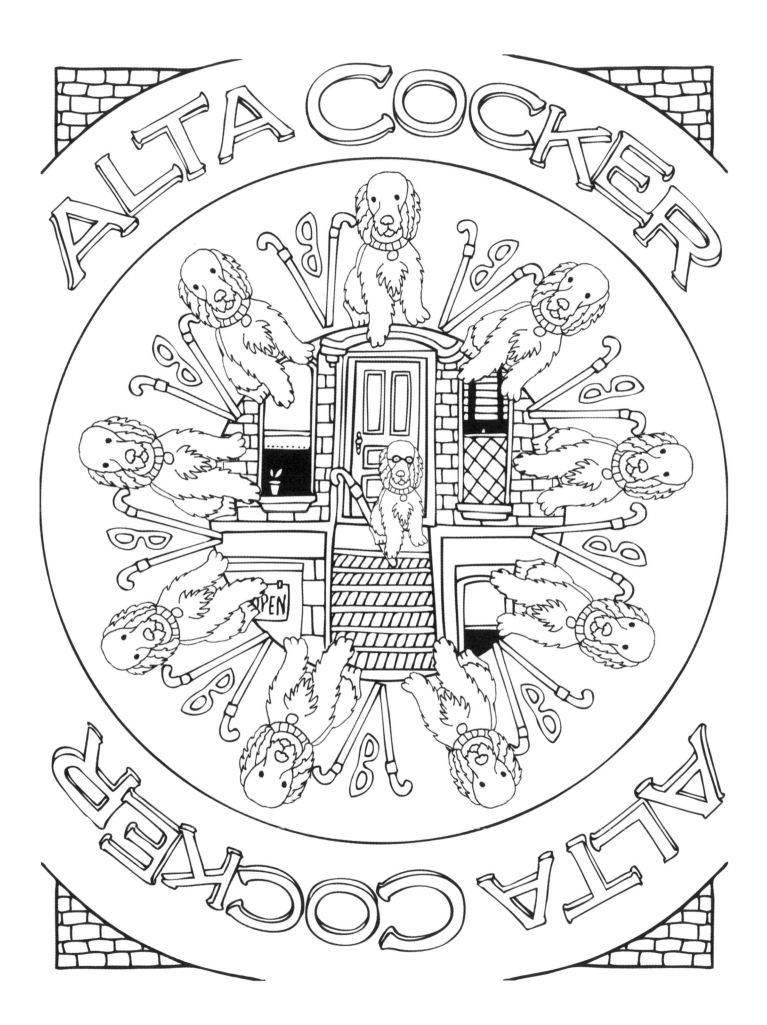

Bubby and Zaidy

BUH-bee **ZAY-dee**

A *bubby* is a grandmother.

A *zaidy* is a grandfather.

Leah's *bubby* and *zaidy* are very old.

How very old?

Their Social Security numbers are 3 and 4.

bubeleh

BUB-uh-luh

Bubeleh means "sweetheart."

Jason said, "I don't want to go to school.

The teachers don't like me.

The students don't like me."

His mother said, "*Bubeleh*, you have to go to school.

You're the principal!"

chutzpah

KHUTZ-puh

Chutzpah is nerve or gall.

Sheila ran into her ex-husband at a restaurant.

He asked her, "Why did they let you in here?

This is supposed to be a nut-free establishment."

What *chutzpah* he has!

GELT

Gelt means "money."

Lots of people worship *gelt.*

But I say *gelt* isn't that important.

I only need it in case I don't die.

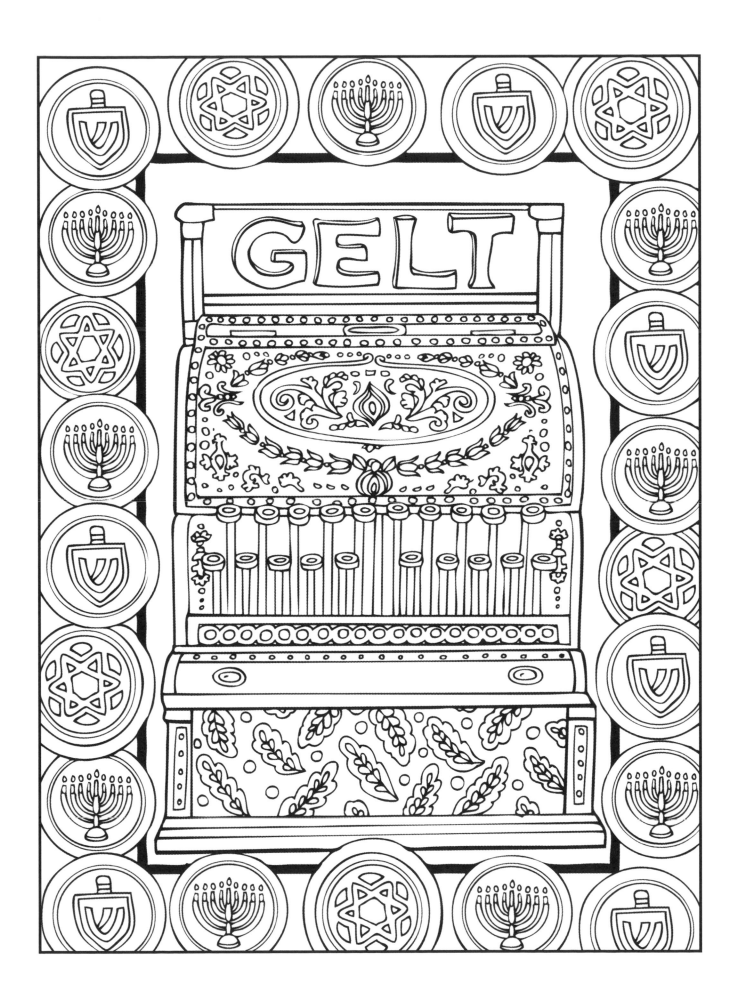

gevalt

guh-VAWLT

Gevalt is a cry of surprise or desperation.

———◆———

Gevalt! Robyn is such a slow pianist!

It takes her an hour and a half to play "The Minute Waltz."

Gevalt!

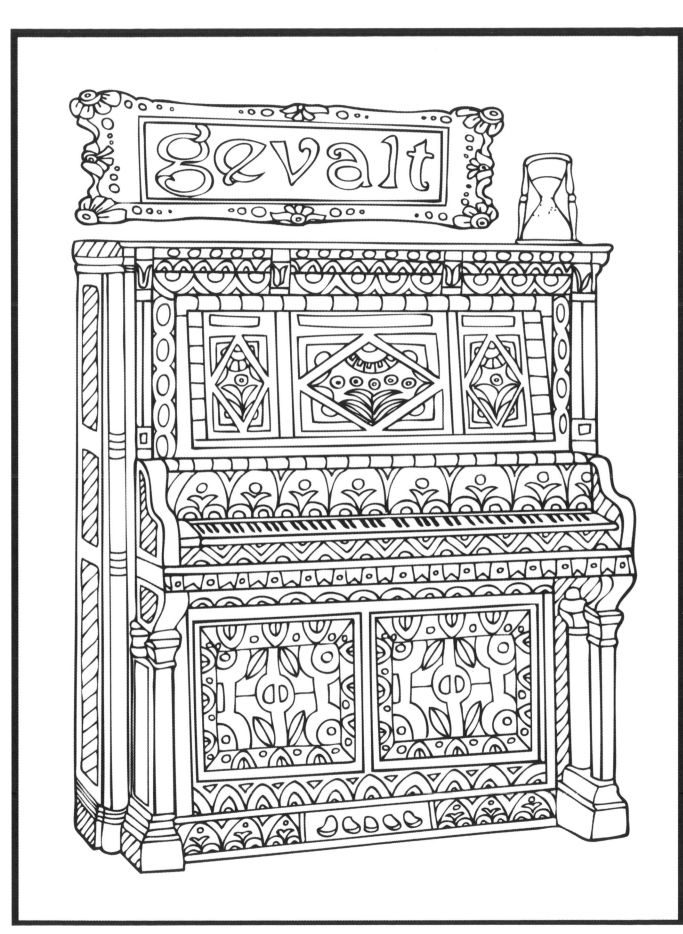

gezundheit

guh-ZUND-hite

Gezundheit means "God bless you" or "to your health."
It is often said to someone who just sneezed.

You didn't know *gezundheit* is a Yiddish word?
The Yiddish language is nothing to sneeze at!

GEZUNDHEIT!

gornisht

GOR-nisht

Gornisht means "nothing."

Marty's acting career has come to *gornisht*.

I once saw him on Broadway.

He was hailing a cab.

kinder

KIN-dur

Kinder means "children."

My *kinder* asked me,

"Who owned a computer in the Bible?"

"I don't know," I replied.

They said, "Adam and Eve. They had an Apple."

Oh, the precious things *kinder* will say!

klutz

KLUHTS

A *klutz* is a clumsy person.

Jacob is such a *klutz*.

He broke a leg while playing soccer.

Worst of all, it was *my* leg!

That *klutz*!

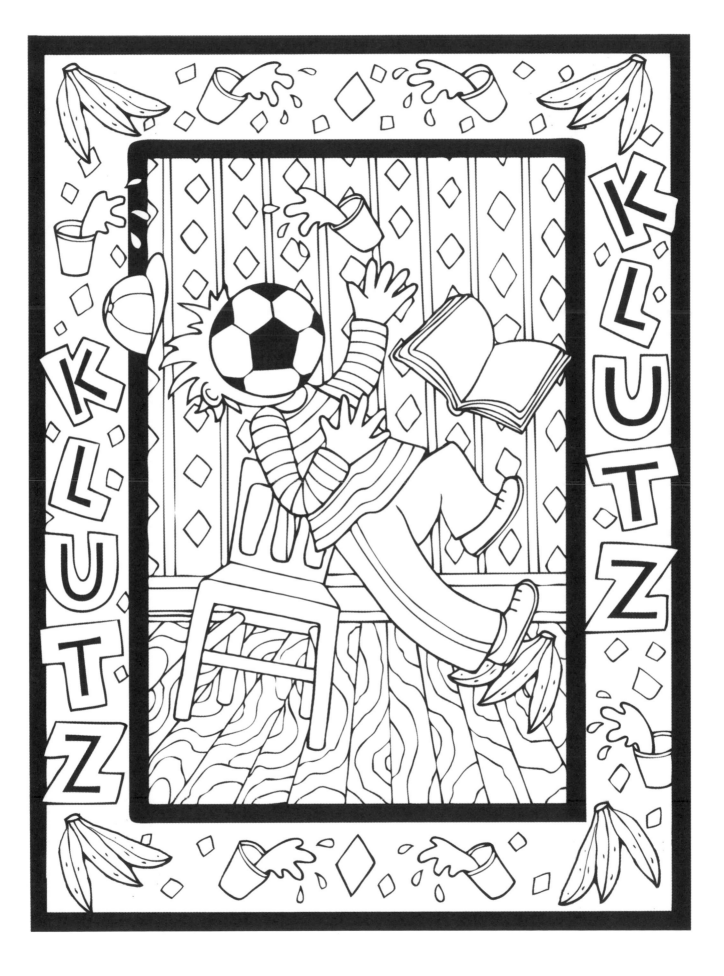

kvell

KVEL

Kvell means "to gush with pride."

Helen likes to *kvell* about her loving son.

"He goes to an analyst," she says.

"He pays three hundred dollars an hour.

And he talks about me the whole time!"

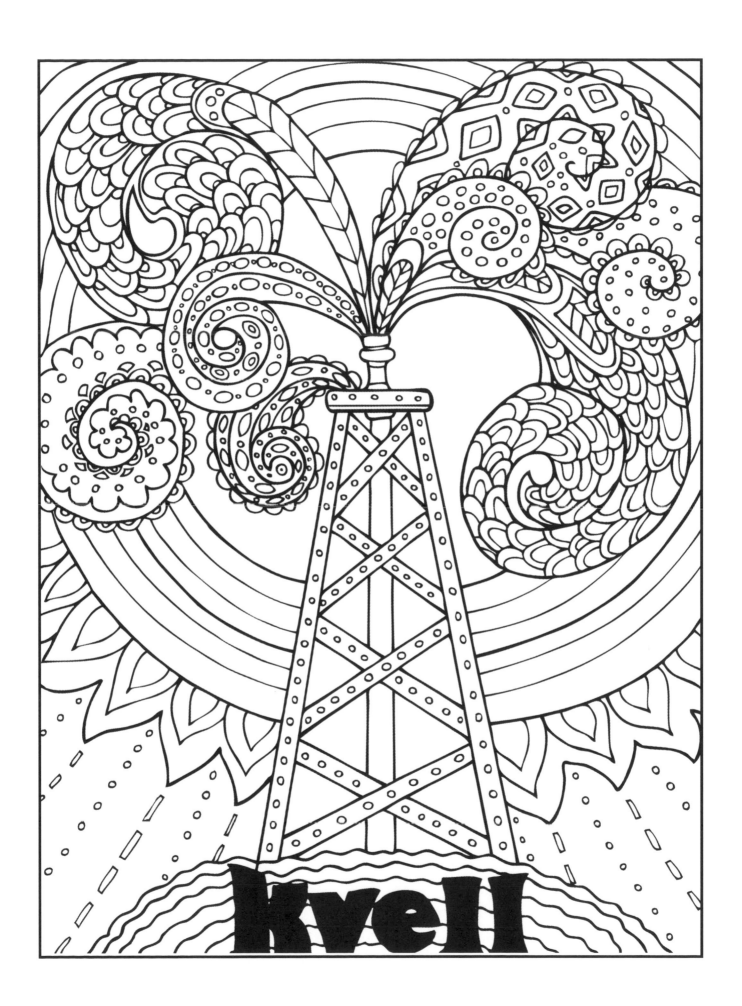

macher

MOKH-ur

A *macher* is a big shot.

Bernard likes everyone to think he's a *macher*.

He brags that he goes to the theater every night.

It's true. He's an usher.

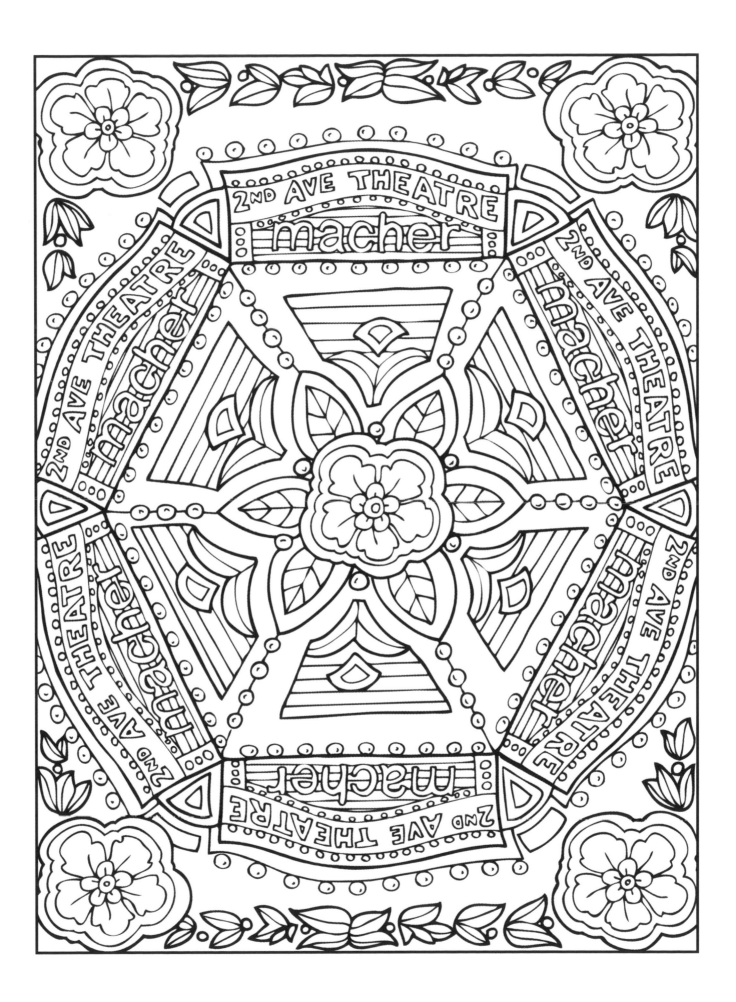

mamzer

MOM-zur

A *mamzer* is a hateful person.

There are two sides to every story.

Your side . . .

and the *mamzer*'s.

maven

MAY-vuhn

A *maven* is an expert.

Rachel is a math *maven*.

She can count pi to 20 digits:

3.14159265358979323846.

Her husband is a dessert *maven*.

He can eat pie with 10 digits:

8 fingers and 2 thumbs!

mazel

MAH-zuhl

Mazel means "luck."

After Josh opened an umbrella store,

it rained for a whole month.

What good *mazel*!

Then his store got washed away in a flood.

What bad *mazel*!

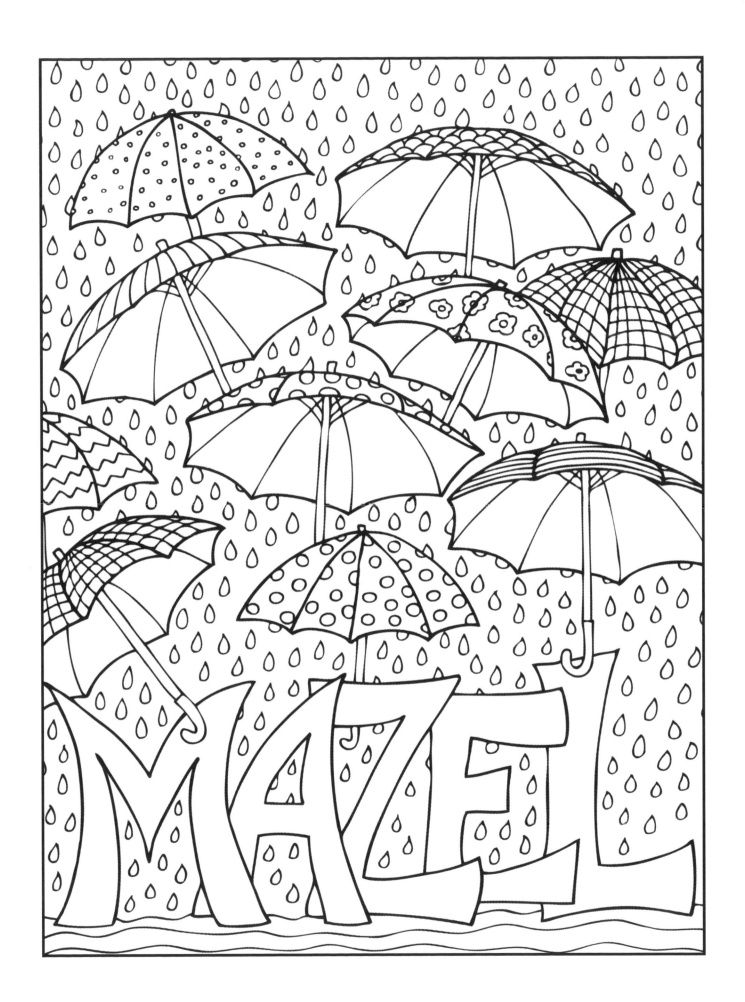

mensch

A *mensch* is a kind, thoughtful person.

Sheldon is such a *mensch*.

His wife wanted a new can opener.

He bought her an electric can opener.

She wanted a new knife.

He bought her an electric knife.

Let's hope she doesn't ask for a new chair.

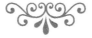

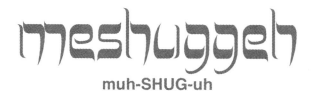

meshuggeh

muh-SHUG-uh

Meshuggeh means "crazy."

Sylvia is totally *meshuggeh*.

She wears her fur coat in the hot summer.

She wears it even when it's 120 degrees outside.

But to tell the truth, it's a nice coat.

nachas

NOKH-uhs

Nachas means "pleasure."

Joel has grown totally deaf.

He doesn't mind.

He gets *nachas* from the peace and quiet.

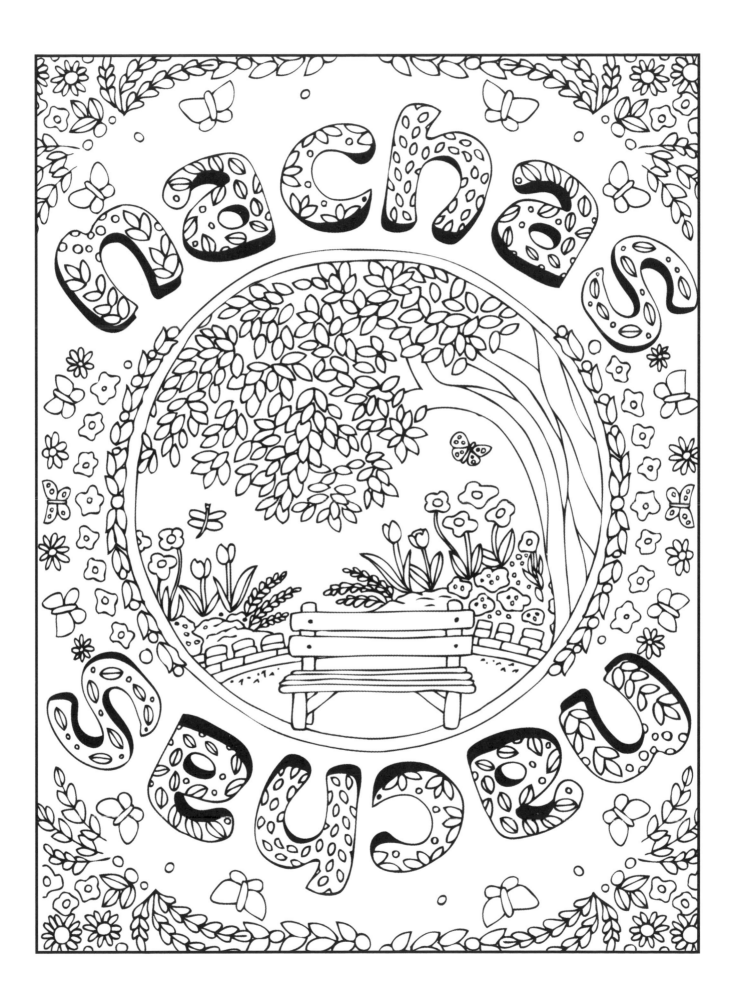

NOSH

When you *nosh*, you snack on food.

———◆———

Myron loves to *nosh* on marshmallows.

He once dreamed that he ate a giant marshmallow.

When he woke up, his pillow was missing.

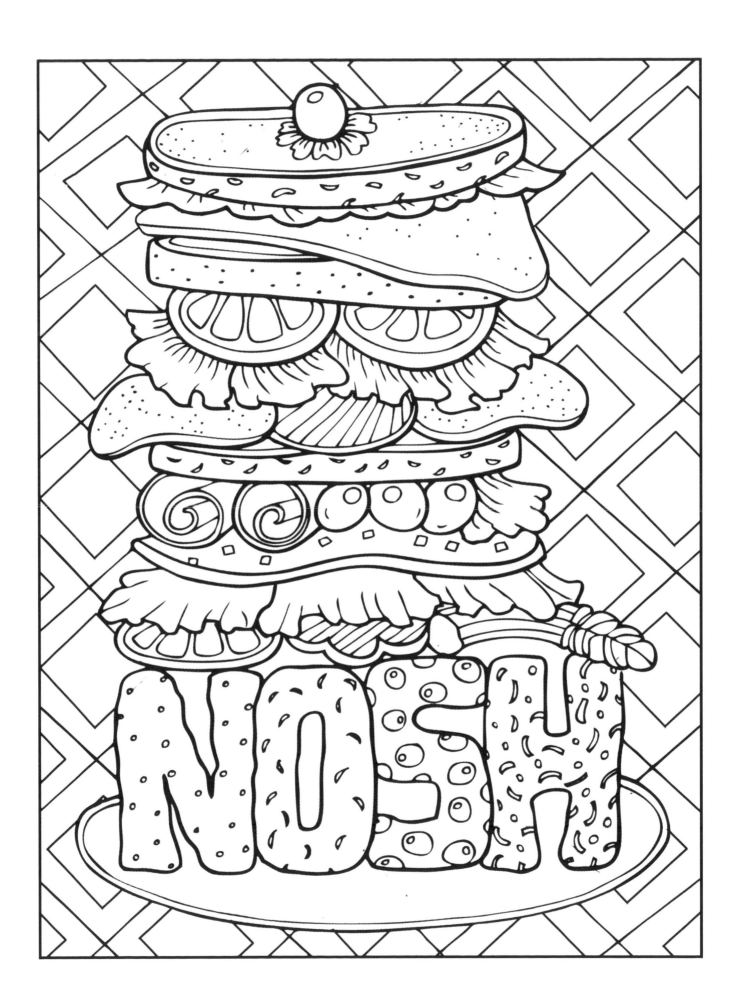

NOO

Nu? means "So?"

Rita's fiancé promised her the sun, the moon, and the stars.

That was yesterday.

"*Nu?*" Rita asks. "What's taking him so long?"

nudnik

NUD-nik

A *nudnik* is a pest or nag.

My neighbor is such a *nudnik.*

He's always asking me how to spell words.

I say, "*Nudnik,* why don't you use a dictionary?"

He says, "How can I find the word in a dictionary

if I don't know how to spell it?"

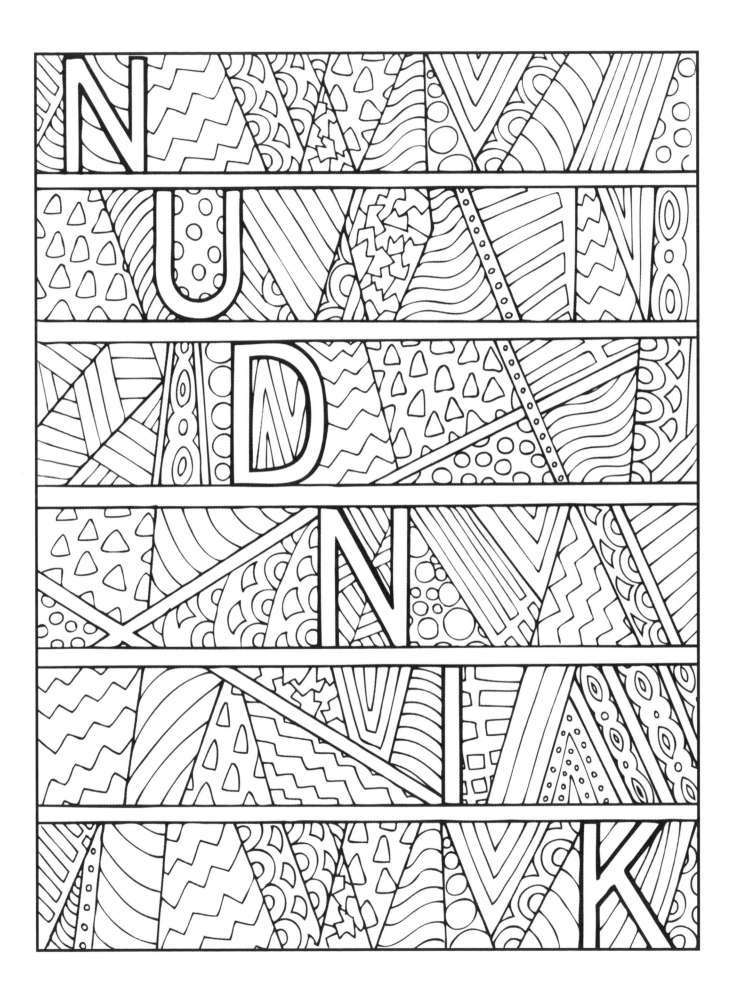

Oy, vey
OY VAY

Oy, vey means "Oh, woe!" or "Oh, no!"

Alan drove through two red lights.

Oy, vey!

They were on the back end of a truck.

Oy, vey!

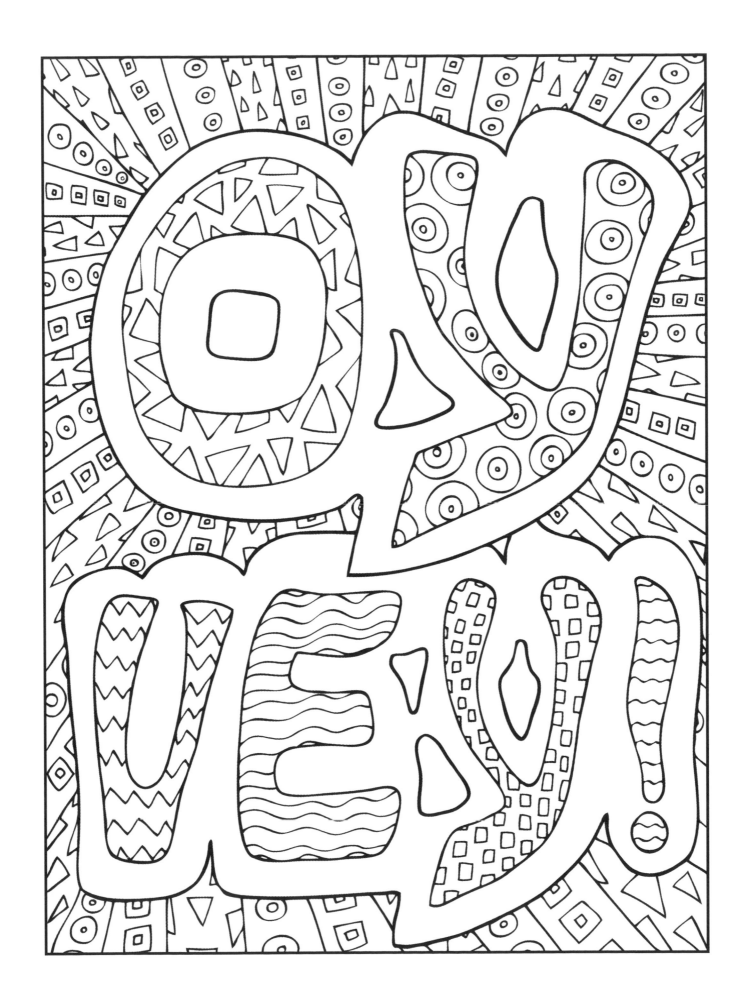

plotz

PLOTS

When you *plotz*, you faint or are overwhelmed with emotion.

My five-year-old grandson told me the cutest riddle:

What's the best kind of cheese to eat on Passover?

Matza-rella.

I laughed so hard, I thought I would *plotz*!

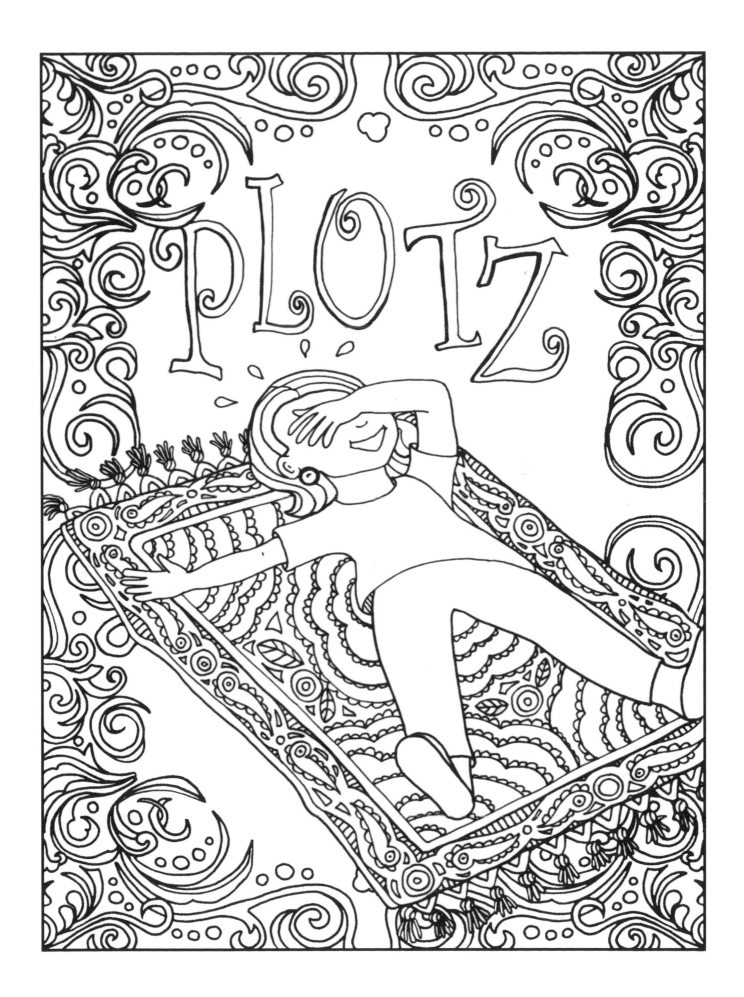

potchkeh

POTCH-kuh *or* **POTCH-kee**

Potchkeh means "to fuss with."

———◆———

Georges Seurat was a famous French painter.

He created pictures by blending thousands of tiny dots.

That guy could really *potchkeh* with a canvas!

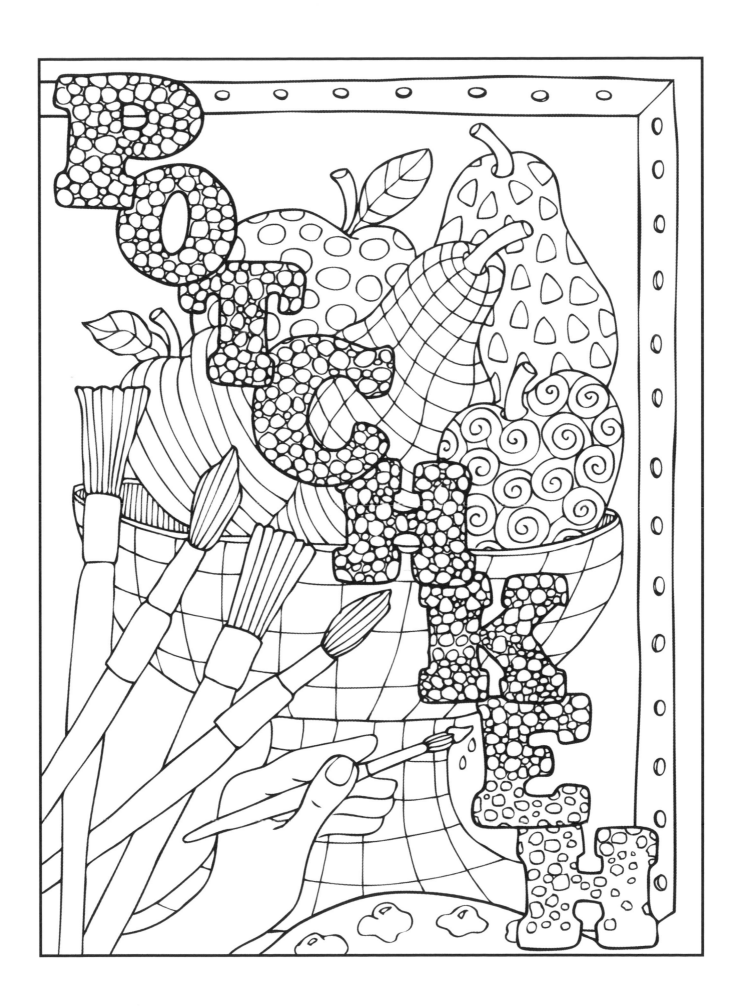

SHLEP

Shlep means "to carry or drag something."

Eli the synagogue cantor has a hernia.

He can't *shlep* anything heavy.

He can't even carry a tune!

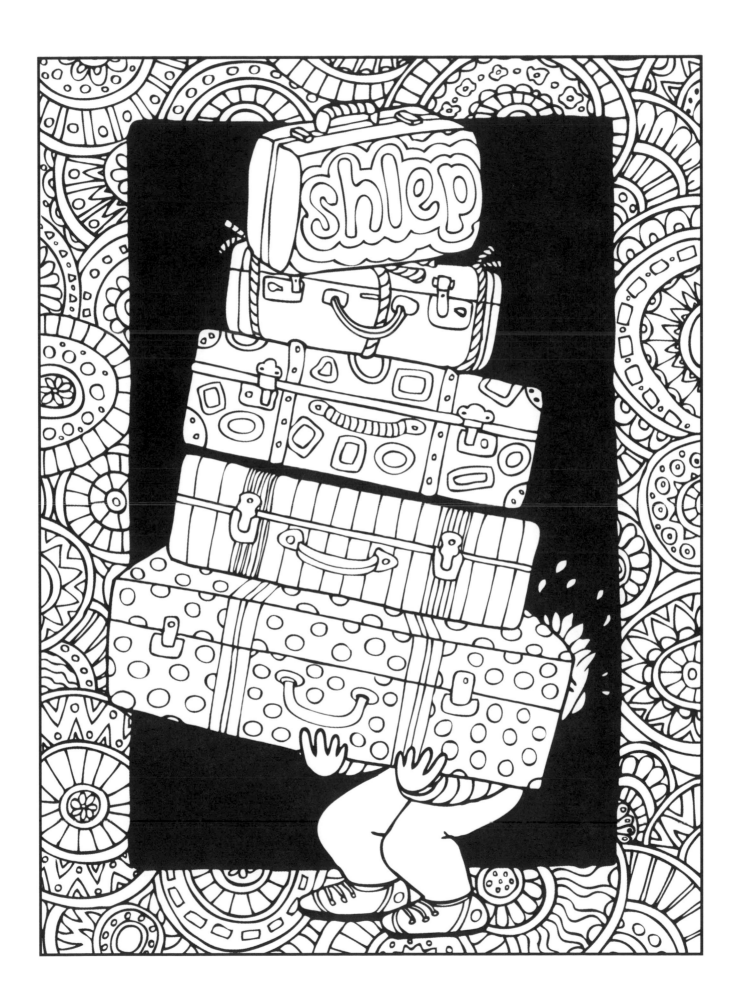

shmatah

SHMOT-uh

A *shmatah* is an old, worthless clothing item.

Are you wearing that *shmatah* to the party?

Oh, you made it in sewing class?

On you, it looks gorgeous!

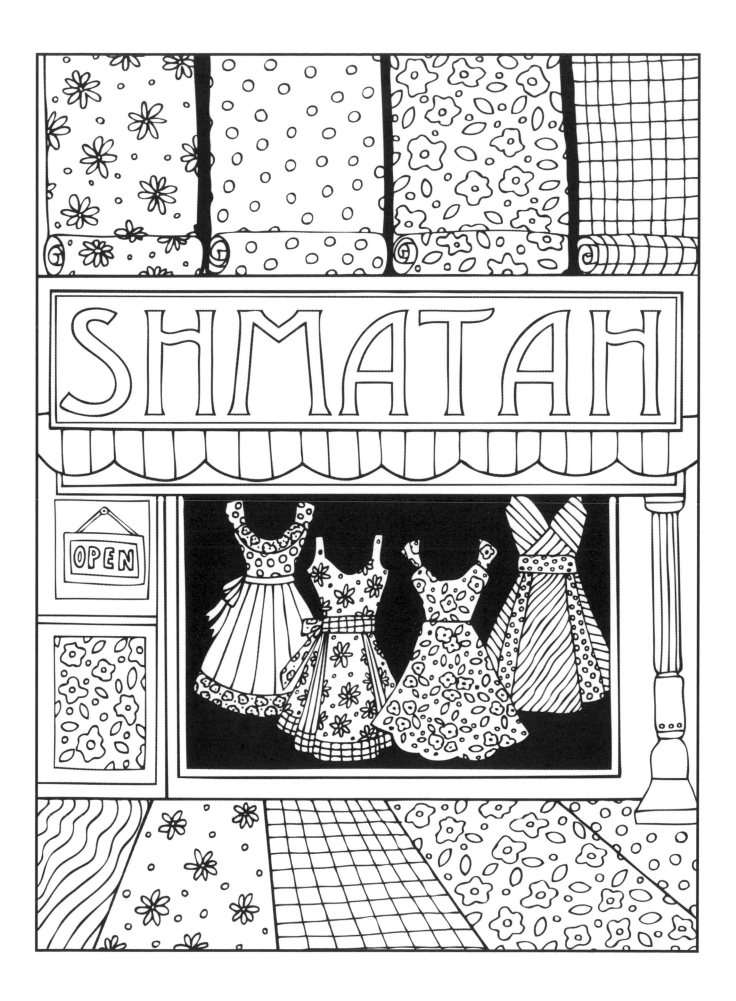

shmear

SHMIHR

A *shmear* is a smear or spread.

At the hot dog stand, I ask for a frank

with a *shmear* of mustard.

The Zen Buddhist next to me had a different order:

"Make me one with everything."

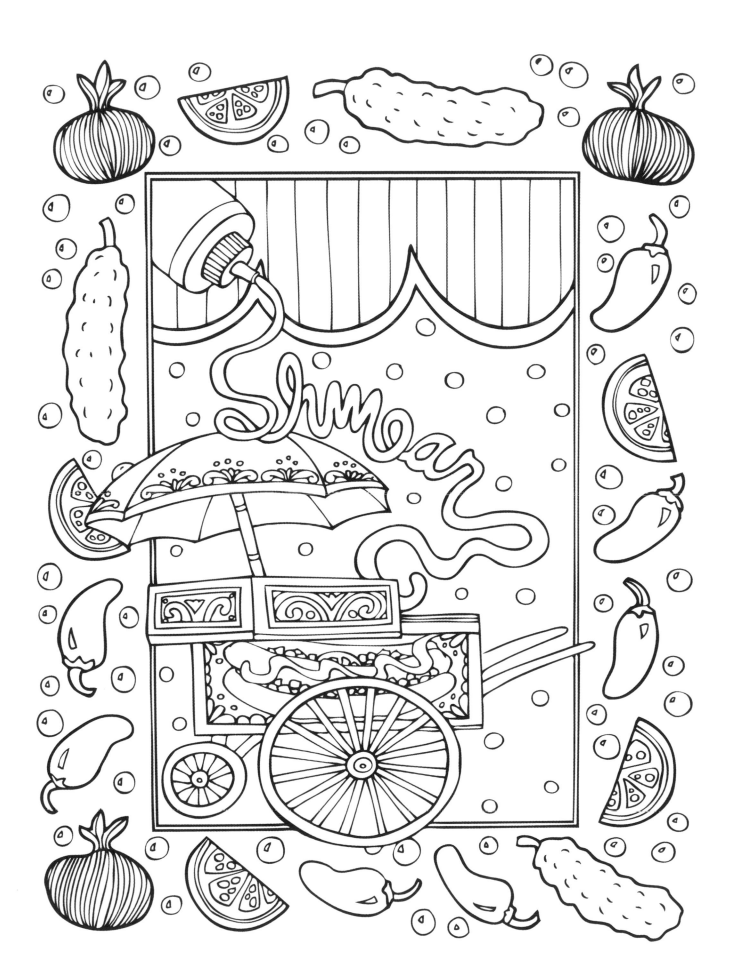

shmooze

SHMOOZ

Shmooze means "to chitchat."

Jews love to *shmooze.*

The comedian Jackie Mason says,

"Gentiles leave and never say goodbye.

Jews say goodbye and never leave."

Why? Because Jews *shmooze*!

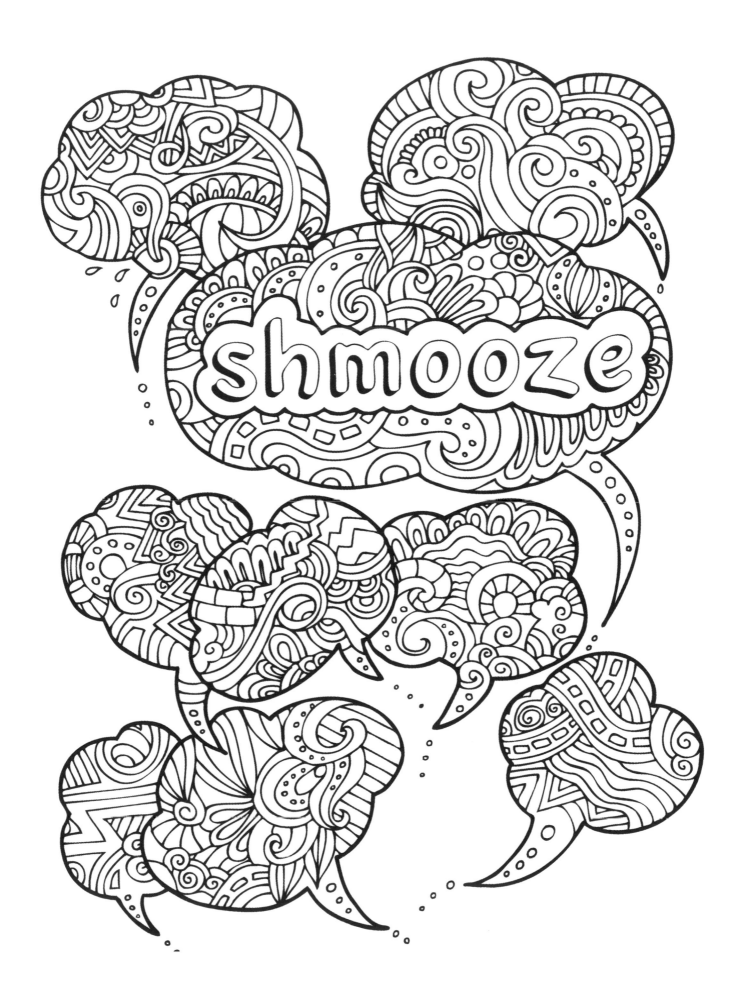

shmutz

SHMUTS

Shmutz is dirt or grime.

Jake is a bachelor.

His apartment is covered with *shmutz*.

That's because Jake hates four-letter words.

Like "wash" and "dust."

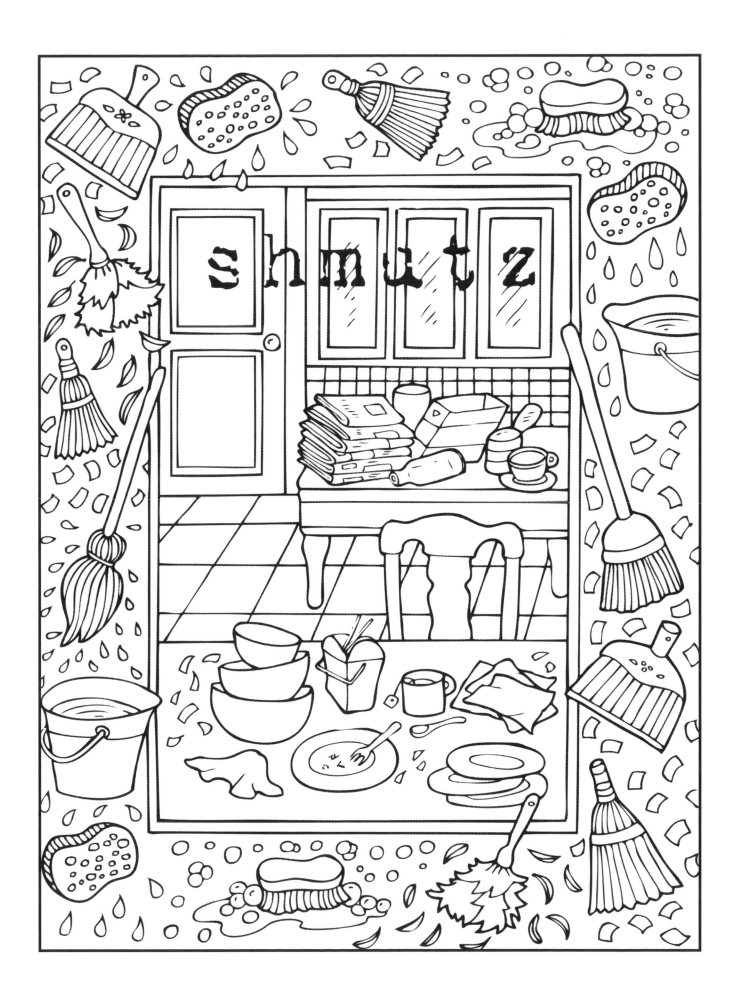

shonda

SHON-duh

A *shonda* is a scandal or great embarrassment.

Did you hear?

The Goldberg boy robbed a United Jewish Appeal office.

What a *shonda*!

He got away with $18 in cash

and $25,000 in pledges.

tchotchkeh

CHOTCH-kuh

A *tchotchkeh* is a small, decorative object; a trinket.

"How much for this *tchotchkeh*?" the shopper asked.

"Three dollars," the clerk replied.

"Three dollars?!" the shopper cried. "It's worthless!"

"I'll give you two for five dollars," the clerk offered.

"Now you're talking!" said the shopper.

tsuris

TSOR-uhs *or* **TSUR-uhs**

Tsuris means "trouble."

———•———•———

Charley has such *tsuris*.

His children won't visit him.

They won't call him.

They won't write him.

Oh, what Charley's children won't do for him!

tuchus

TUKH-uhs

A *tuchus* is a rear end.

Stefanie sits on her *tuchus* all day.

But she has a good excuse.

She's a Pilates instructor.

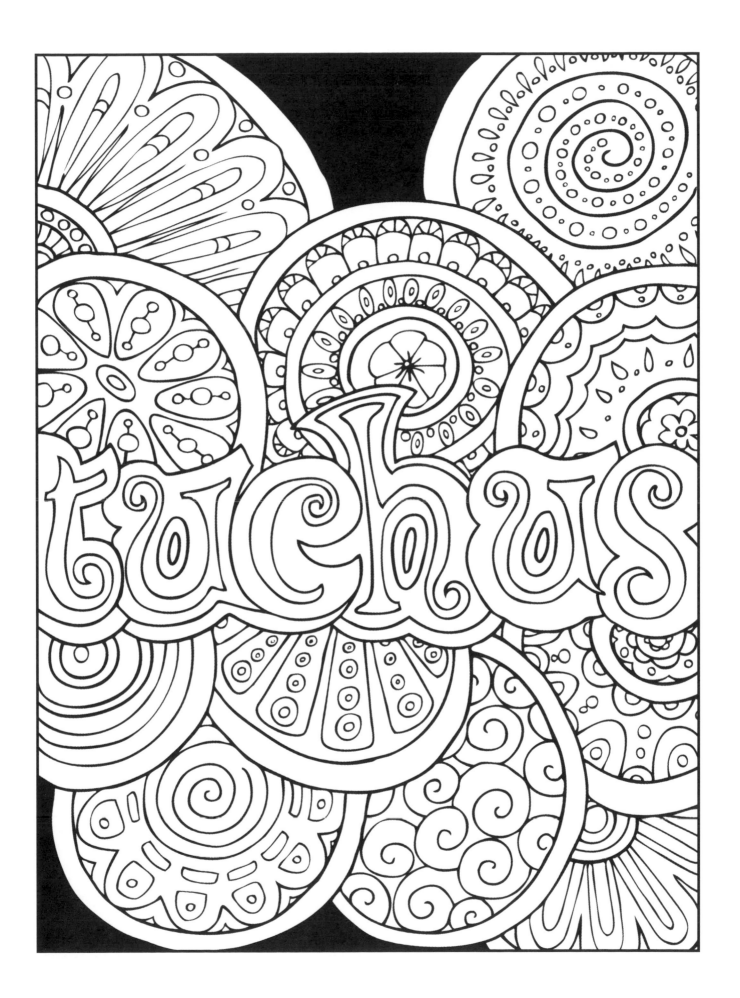

yenta

YEN-tuh

A *yenta* is a nosy person; a busybody.

My optometrist is such a *yenta*.

I told her I'm seeing spots.

She asked, "What's Spot's last name?

And how long have you been seeing him?"